D1067084

THREADS OF LIFE

Turning Children's Original Artwork Into a Quilt Legacy

Molly M. Todd

Threads of Life

Introduction

It was a tearful goodbye on my final day of teaching. The middle school in which I had taught art and mathematics for 23 years, housed the county's Hearing Impaired Unit and the deaf kids were regularly assigned to my math classes. Deaf is their preferred descriptive term, by the way. They told me that "Hearing Impaired" makes them feel like something is wrong with them. I always enjoyed the lively atmosphere of a classroom filled with aids and interpreters. But, as I explained to the children on that October morning that I'd been given an opportunity to retire earlier than expected, the tears began to fall. My tears, of course, not theirs. Children are so resilient and by afternoon they had all but forgotten. As I blubbered out my explanations and goodbyes, three interpreters whined in youthful voices. They cried out, "It's OK Mrs. Todd" and "Don't cry Mrs. Todd" while the children to whom they gave voice, signed emphatically. I was only 60 years old and still full of energy and enthusiasm but some changes in educational policy were forcing me to become a renegade when I had always been a team player. I didn't like the feeling. It was time to move on to a new adventure.

I set about the task of building the perfect retirement. Teaching a couple of math classes as an Adjunct at the local university gave me my required fix of interactions with young people. I knew that a perfect life for ME would also have to include singing and dancing so I found a "dance aerobics" workout class and joined a 500 member choir in my community. Of course there were false starts along the way. The exercise class with the rocking music and dance was not the first

one I tried. The big choir required nearly a year-long wait on the waitlist. But with patience

and persistence, I was finding lovely ways to spend my days. Taking a "Manifesting" class,

reminded me to ask the Universe for what I want and then trust that it would be given. I

changed my lifelong habit of aggressively pursuing my desires, to one of trusting that the

Universe would send me what was in my greatest good at that time. I expressed gratitude daily

for what had come and what was coming. High on my list were creative expression and deeper

connections with others.

One night at choir rehearsal I met a woman named Linda. Linda and I were just drawn to

each other and bonded quickly as you do sometimes with special friends. It didn't take long for

Linda to discover that I have a degree in Fine Art, taught art for a few years and like to make

stuff. She asked me, "Molly, do you sew?" I told her that I've sewn all my life and can do just

about anything on my little 1970's Singer machine. One day she invited me to join her at a

meeting of her quilt guild. I declined the offer as I had no interest in quilting and honestly

imagined women sitting in a circle, possibly wearing bonnets of some sort; not that I have

anything against bonnets or those who wear them. I knew nothing at all about quilting and

understood it only as a way to make a bedspread. I was not in need of a bedspread and figured

it would take an incredibly long time to make one anyway. Linda was persistent. About a

month later, she asked me again to come with her to a quilt guild meeting. As I was about to

decline for a second time she said, "There will be a great speaker that I know you'll love. We

always have great speakers!" Now I was truly perplexed. What could a speaker possibly have

to say about making a bedspread? But, I wanted

to honor Linda's persistence. I agreed to go but not without a bit of eye-rolling to make my point.

The experience turned out to be no less than life-altering. The day came and Linda took me to a meeting room near the local college campus. Today was some sort of "reveal" for the group so when I walked in to that room, the walls were lined with the most beautiful pictures made out of fabric! I had never seen anything like this before. It would not be an exaggeration to say that I was struck, as if by a lightning bolt. I have a passion for fabric and I knew immediately that I was meant to do this. I paid my dues and joined the group. Long story short: A top of the line sewing machine was purchased and within a couple of weeks I took off like a racehorse out of the gate. This machine with all its bells and whistles could produce literally hundreds of different stitches. But rather than create practice pieces, as was suggested by my fellow quilters, I decided to learn while making my first quilts. I chose the theme of scenes from nursery rhymes because if the quilts didn't sell, I could just give them to my grandchildren. After researching online and looking at picture books, I created my own drawings and simply translated them into fabric. These quilts were small (about 20" x 24") and exhibited the many different stitches with which I was becoming familiar.

I had taken over the dining room with my new obsession so, by the time I completed three nursery rhyme quilts, my husband gently suggested that I find a new home for them. With quilts in hand I walked, unannounced, into Cover to Cover Children's Bookstore. The owner happened to be there. She took one look at the quilts and she said, "Oh. I must have these. I will buy them

all." I showed her pictures on my phone. They were drawings of possible future quilts in the Nursery Rhyme series. She said she wanted to buy those as well, and they hadn't even been created yet! Then she said, "Could you make two more in addition to those? Maybe something with mice since my store logo has a mouse?" Well, I certainly could and I certainly would! Now, you might be thinking, Wow, what an amazing story. And it is. But it was just the beginning. Because the story continues to unfold and become more and more amazing with time. I can only describe the events as spiritual in nature and I could not have known on that eventful day, the wonder that lie ahead.

Seven Nursery Rhyme quilts were delivered a few weeks later and I helped my new friend, Melia, hang them above the bookshelves inside the front door. They fit so perfectly and really brightened up the shop's entryway. Melia had suggested that I have business cards created. She promised to keep them on the sales counter and hand them out when customers asked about my work. I was incredibly proud and excited as I placed my little leather holder full of pink business cards on that counter. And yet, a small concern lay just under the surface of my excitement. The art quilts I'd seen at Art Quilters Alliance meetings were extremely abstract and deeply artistic. I could not possibly create such work or even imagine how it was conceived. That is exactly why I had chosen to begin with pictures that were simple and clean and easy to replicate in fabric. What if a potential customer contacted me and requested something more abstract? But, I figured with enough time and enough practice, I could learn just about anything so I refused to worry.

As I thanked Melia and turned to leave the bookstore, she stopped me. Reaching up behind the cash register, Melia pulled a small framed picture right off the wall. It was a watercolor of a

mouse and he was saying, "Please Read". It was a charming picture and, obviously, the work of a child. She explained to me that her son had made this picture for her when she opened the bookstore and she asked if I could turn it into one of my quilts but much larger. She wanted to put it over the reading couch at the back of the store so children could snuggle up. I told her that I supposed I could but that I would need to have permission from the artist before I would do it. As a former art teacher, it is very important to me that children understand that they have ownership of anything that they create. I make a big deal out of asking children permission to copy their work. As luck would have it, Melia's son was right there in the back of the store working with his tutor. The tutor turned out to be a former student of mine and it was a warm reunion.

Max is a delightful young man. He has Autism. When I explained his mother's request and asked for his permission, he thought for a moment and said, "Well.............If you don't see a little c with a circle around it.........then I guess it's ok." He was, of course, referring to a copyright symbol. I clapped my hands and told him I didn't see one! I thanked Max and went right to work. Creating The Mouse Quilt prompted a huge awakening for me. I was combining my love of children's original artwork with my love of fabrics and I knew I had found a calling. I no longer concerned myself with the abstract and artistic beauty of my fellow guild member's work. I knew that THIS was what I wanted to do with art quilting.

I perfected my technique while creating quilts from my grandchildren's artwork. They allowed me to use their special quilts as examples for potential customers, as well. I began to get the occasional call from the bookstore business cards and; eventually, from referrals.

Sewing became a joyful creative outlet. But, the Universe was not finished with the mini miracles that continue to shape this story.

About four months after beginning to quilt, I met a woman named Tina. We were chatting and when she asked me about myself, I included the fact that I make quilts that replicate children's artwork. We chatted a bit more and then Tina suddenly said something a bit startling. She spoke slowly as if thinking the thought for the first time. I will never forget it and can hear her voice even now as I write. Tina said, "Wouldn't it be nice……if you could use your sewing skills to honor children who have died……" It was more a statement than a question. I was taken aback and told her that I honestly was not sure I would be emotionally equipped to work with families who were grieving that kind of a loss. Tina continued. She told me that she had lost her great nephew just two weeks prior. His name was Robby. He was born with Cerebral Palsy and was not expected to live more than a few weeks. Robby lived to be 12 years old. Tina told me that she had some of Robby's last completed artwork. It was done when he was 4 years old and he had lost function in his hands shortly after. Tina knew it would be so meaningful to Robby's mom if the work was replicated in a quilt. As we parted company, I promised to give it some thought. That night I told my husband about this conversation. After dinner, we were sitting on the porch quietly reading and he spoke up. He said, "You know Molly, we really don't need the money that a quilt business brings in. I think maybe you might want to just think of sewing as a hobby and go ahead and make quilts for sick or deceased kids." And with his encouragement, I contacted Tina immediately. During the process of creating Baby Robby's quilt, I felt his spirit close to me and heard him laughing frequently.

When his mother, unexpectedly, texted me a photo of Robby, I was stunned. The laughing face before me was so very familiar. It took my breath away.

I continue to make quilts for families who are blessed with health and are able to pay, but I make sure that they understand how their purchase allows me to honor more children who are dealing with critical illnesses. Fine fabrics are not inexpensive and the quality of the materials I choose is, for me, a high priority. I want my quilts to last for many generations. The idea of legacy looms large in the quilting community and has found its way into my thinking, as well. What was once only about the joy of "getting inside a child's head" in order to recreate their artwork, has grown into something more. That joy now includes the possibility of creating a very personal legacy. One that captures the essence of that child through their own creativity.

I was very nervous on the day that I delivered Robby's quilt to his mother. Her name is Angel and it could not be a more fitting name. Angel spent time with me on that morning, showing me photos of Robby's short life and I managed to control my emotion fairly admirably. It was decided that she would act as a sort of liaison for me in connecting with other families who might be interested in what I do. The process was helpful; especially since it was early in my experience, but it was slow. I knew I could do more. Shortly after that thought crossed my mind, a text arrived from my friend, Linda. Linda wrote to me, "Call Ronald McDonald House". It was much more a directive than a suggestion. We happen to have a very large Children's Hospital in our town. We also have the distinction of the largest Ronald McDonald House in the World. I contacted them and met with the power people. They liked what I do. They gave me free access to the families they serve. I go over on a Sunday evening and set up a display table at supper time in the dining room. I explain what I do to families, ask children for permission to

copy their work, and end up with as many quilt jobs as I can handle. I am currently presenting these quilt gifts to the families of critically ill children at the rate of one per week. It would be impossible to describe the pleasure I get from analyzing a child's work and trying to duplicate it in fabric. I am sincerely thankful to The Ronald McDonald House Charities of Central Ohio and honored, beyond measure, to work with such strong families and brave children.

You are going to meet some of those families. You will hear their stories and see the honesty, whimsy and charm of each child's original artwork. As you do this, it is important to me that you remember something. Not one of the events that led to my work with these children was my own idea. Linda's persistence allowed me to discover "art quilting". Melia at Cover to Cover Children's Bookstore requested that I make a quilt from her son's artwork. Tina suggested using this idea to honor critically ill children or those that have crossed over. And, Linda directed me to the children at Ronald McDonald House. I consider these interventions no less than divine and I am grateful.

Everyone has a story. I don't believe there is a single soul walking the Earth today that does not have a profoundly relevant book somewhere within their life experience. My hope is that these children and their families find comfort in the telling of their stories and that you, the reader of these stories, find a personal connection; an emotional connection that provides you comfort as well.

Once upon a time, a talented stranger visited Cover to Cover bookstore. She had an armful of wonderful quilts depicting all of our favorite nursery rhymes. As soon as we saw them, we

knew they would be perfect to decorate and sell in our store. So many of the readers who have come through the store have been awed and inspired by the iconic scenes. Molly's background in teaching art and math uniquely qualifies her to these pieces of art that are so appealing to children. Our son Max immediately liked Molly and was excited about her vision, and he created a unique design that she replicated beautifully using fabric. Melia Wolf

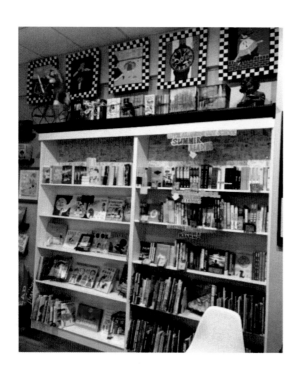
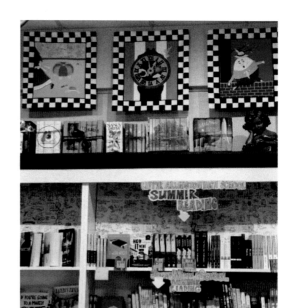

"I painted the picture of the mouse at Picasso's (an independent art studio nearby). The mouse is based on the Cover to Cover mascot. He is saying "Please Read". Molly matched my drawing and colors very well on the quilt. Molly is nice and she is a great artist." -Max Wolf

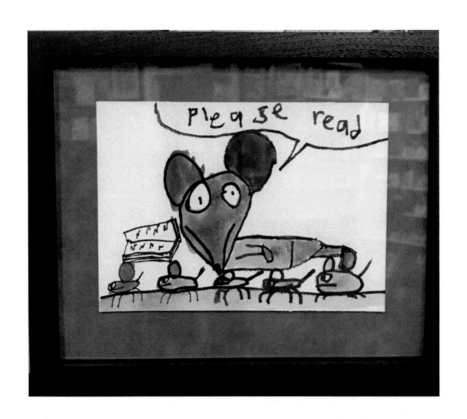

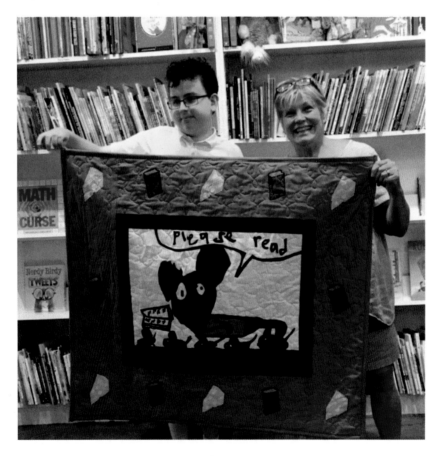

Strong Families – Brave Children

You have read about my encounter with Tina. I had known her for less than fifteen minutes when she suggested that I make quilts for children who are critically ill or for the families of children that have died. Her suggestion set me on a rich and rewarding path. The artwork Tina gave me was done by her great-nephew, Robby, when he was four years old. It is one of his last pieces of art as he lost function in his hands shortly after it was made. It is an Easter egg, painted with finger paints and signed with Robby's feet. I replicated this artwork in quilts for Robby's mother and his grandmother, as well as for my personal collection.

In Angel's words…….I was 16 years old when I found out I was pregnant. A junior in high school. Being that young I was terrified. My baby was wanted from the day I found out. I couldn't wait to become a mom. Throughout my pregnancy my baby and I were completely healthy. I was having a boy. We had his name picked out already. Robert Jennings Biggs III. He was named after his dad. Come September 5th 2006 the day arrived that I'd bring my son into this world. At 7:07 pm he was here. I had some complications during delivery and Robby was taken to the NICU (Neonatal Intensive Care Unit). He was evaluated and diagnosed with seizures. Then the devastating news came, he had suffered severe brain damage. He couldn't control his hands, arms or legs. We spent 6 days in the NICU hospital until we were transferred to Nationwide Children's Hospital in Columbus, Ohio where he received amazing care. At this time Robby was not able to eat by mouth. He was born with no gag or suck reflex. So he had to be fed by a tube through his nose. He had multiple IV's and all kinds of wires attached to

him. After days in the NICU we found out he was cortically blind, meaning his eyes were great but the nerves connecting to his brain were bad. Fast forward a bit. We spent 30 days in the NICU. We were uncertain of Robby's future and each day was a blessing. When he was 3 months old we got the diagnosis of Quadriplegic Cerebral Palsy. This meant that the lack of oxygen to his brain during birth had affected all four limbs. At this point he was now diagnosed with severe brain damage, seizures, cordially blind and Cerebral Palsy.

As Robby got older, more diagnoses were added to his chart. We did learn he could see light and dark. He hated for the lights to be off. He did gain his gag and suck reflex back and was, eventually, able to take a bottle and eat baby food. He did use our finger as a pacifier and boy was that painful. Around 8 months old he had an allergic reaction. We gave him Benadryl and found out soon after that he was allergic to that. It had increased his seizures significantly. We had never physically seen one until that time. I realize I may be skipping ahead quite a bit but I'm giving the main points in Robby's life.

When Robby was 2 years old, his seizure medication had an adverse reaction. It caused more severe seizures. Within 24 hours he had over 300 seizures. They had to induce him into a Pentobarbital coma so that his brain could rest. When he woke up from that he had forgotten everything. He could no longer eat by mouth so he had to have a tube placed in his stomach and was fed by a pump. He could no longer army crawl or walk with assistance. We lost it all.

Every time we had a surgery we lost something and never got it back. He had Scoliosis bow at this point. He had multiple hip surgeries. Along with g-tube surgeries, Hernia repairs, and Heart surgeries. In 2010 he was diagnosed with Necrotizing Fasciitis. This is a flesh eating bacteria that normally causes death within 24 hours. My baby beat that but we spent 3 months

in the hospital because of it. They had to cross his stomach over to the opposite side. He had been through so much; multiple therapies, doctor's appointments. You name it, this little boy went through it. The pain he had to endure in his life was so unfair.

In 2013 Robby had siblings. He had twin sisters born at 34 weeks; Arissa and Mackenzie. They loved their brother very much. They didn't see his disabilities and played with him as if he could play back. Come 2015 we found out he needed surgery for his Scoliosis. His curve was so bad that it began to affect his lungs and other organs. After that surgery Robby had gotten so much taller. His health began to improve. Things were calm for a little while. Come 2017, Robby was sick a lot with Pneumonia, on and off for 13 months. It really took a toll on his body. Come summer 2018, we spent some time in the hospital. His hair began to change color and texture. It began to fall out. We couldn't find a reason after many tests. When he was well enough, we got to come home in August. He was sent home on several medications and antibiotics for any infections. He had been on daily medications since birth. We were looking forward to celebrating his 12th birthday coming up on September 5th but we didn't have a big party. Come September 18th, I got his sisters off to school and got him all taken care of. I laid him down for his nap at 11 am and gave him his medication. I went back in less than an hour later to get him ready for my appointment. He wasn't breathing. His eyes were open. His body was warm but he wasn't moving. As I'm on the phone with 911 I'm giving my baby CPR. The paramedics got here and we took the 15 minute ride to Children's Hospital, which seemed like hours. They worked on Robby for what seemed like a lifetime. Shortly after noon they pronounced my baby deceased. I prayed so hard for my baby to come back to me. But I understand his time here on earth was over. For a little boy who wasn't supposed to make it

past a week old, he gave me 12 years. He had taught everyone that was in his life, so much. My baby was no longer suffering. No more pain. He was finally in Heaven with no restrictions to his body. He was your typical boy now. He no longer needed 24/7 care. No wheel chairs. No tubes. No Monitors. My baby was free. It's now been 2 years since he crossed over and it seems just like yesterday.

Any picture that Robby made was precious. He really enjoyed fingerprinting; although, he hated to have his hands cleaned after. Robby made an Easter Egg painting Easter 2010. We did several of them for our family. Each one was unique. For this picture with his feet print it brings back so many memories and smiles. When my Aunt Tina met Molly she knew we would be a great fit for her to make a quilt with Robby's artwork. I was put in touch with Molly not too long after Robby went to heaven. She did an amazing job. The quilt hangs in my living room on a memorial wall for my son. It matches the picture in every way. And I'm so blessed to be able to have such a precious memory of my baby boy.

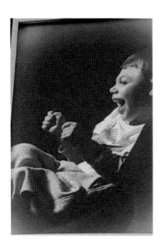

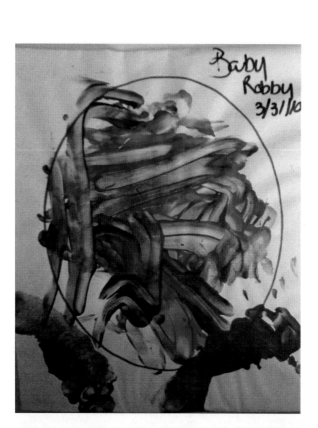

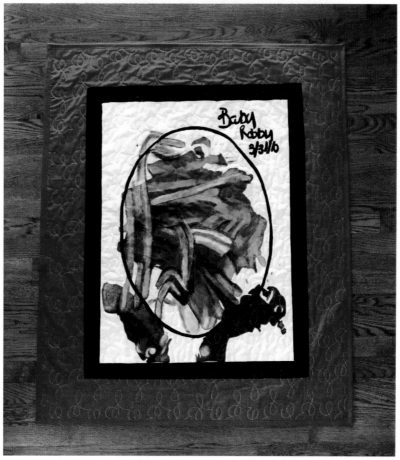

Shortly after I delivered this quilt to Angel, she asked me if I might make a second one for her mother, Robby's grandmother. I was just starting out and was concerned about multiple requests from one family so I said I would not be able to do that. About a year later I duplicated Robby's quilt for my personal collection, remembered that request, and gave it to Angel's mother.

Robby's mother, Angel, referred me to Conaln's family. I was told that Conlan was also born with Cerebral Palsy. He is confined to a wheelchair and must make frequent trips to the hospital for treatments. He wears a band around his waist with wires that are connected for stimulation of his failing muscles. Conlan has a little sister named Sophie. I was texted a picture that Sophie had been permitted to draw on the wall of Conlan's hospital room. It is a picture of "Super Conlan" wearing a cape and accompanied by a love letter from his sister. I was told that Sophie calls her brother "Super Conlan" "because he is so brave". Sophie's mom, Chryssy, was requesting that the note be replicated in a quilt for Conlan to use in his wheelchair as he travels from home to hospital and back. The quilt was to be Sophie's Christmas gift to her brother. I made this quilt from the softest flannel I could find so that it would be super snuggley.

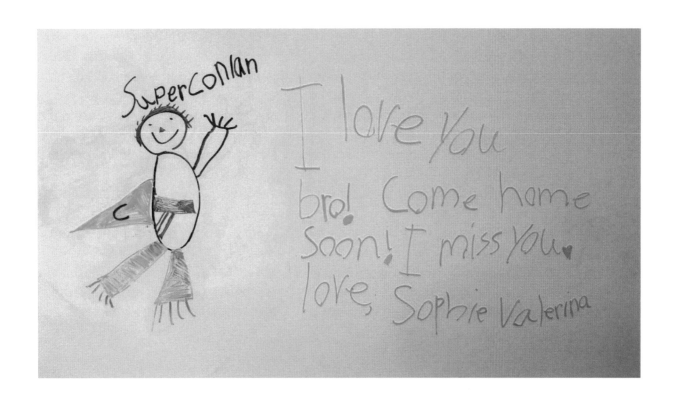

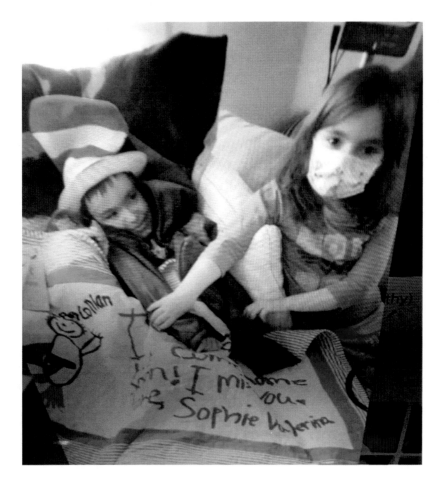

This is the story of Lincoln and Lennon. The boys were born at about the same time with a variety of health issues. For this reason they were both treated at Nationwide Children's Hospital and lived as roommates for most of their first year of life. Lennon lived. Lincoln did not. He passed away at the age of two. We can only imagine how close the families of these two boys must have become; most likely seeing each other daily. You can read more about Lennon and his family online at thelennfoundation.org. Lenn's mother, Alycia, and his Aunt Lindsey formed this foundation to help children with Cerebral Palsy. They raise funds to help families with the overwhelming financial burden of medical treatment not covered by insurance.

I was contacted by Alycia. She told me about her son and his precious roommate Lincoln. She asked if I would please make her a quilt showing a sunflower, as a gift for Lincoln's mother. Alycia explained that the sunflower is Lincoln's sign to his mother. When she sees the flower, she knows that her son is near. Alycia accompanied the request with a very nice sunflower picture from a book or magazine. This presented a dilemma for me. I could, of course, duplicate the picture but after careful consideration, I told Alycia that, no, I would not make the picture into a quilt. It's just not what I do. I asked her, instead, to give Lenn a piece of paper and some crayons and ask him to draw a sunflower. Alycia told me that he could not do that as he has little function in his hands. But somehow, I just felt strongly that a yellow blob on a white sheet of paper would mean more to this mother than any photo from a book. So, I suggested that Alycia take her son's hand into her own and; together, they could draw a

sunflower. This is what they decided to do. The picture came out wonderfully even if it does

resemble the original photo quite a bit! When I delivered the quilt, it was a true pleasure to

meet little Lennon and his father, as well.

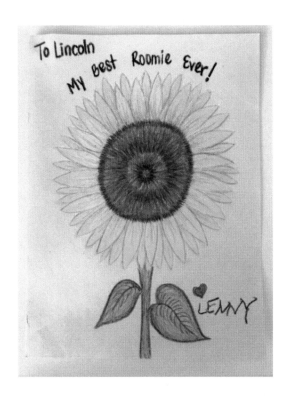 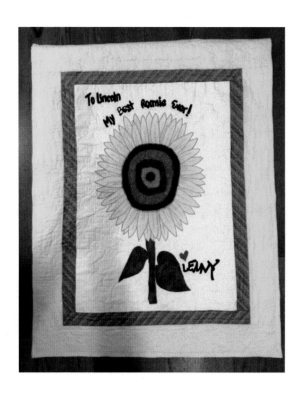

In Jami's words................... My name is Jami and I have three daughters, Lily (11), Mia (9) and Eden (5). All three of my girls have gastrointestinal systems that do not work properly and they require specialized care. My daughter, Mia, was sent to Nationwide Children's Hospital in Columbus, Ohio in October 2017. Lily was sent in July 2019 and Eden in October 2020. Strangely enough, their systems are broken in three different ways so we require several teams at N.C.H. - GI, Colorectal, Neurosurgery, Physical Therapy and Dietician. My girls have had many surgeries and hospital stays over the course of the past few years; both in Illinois at our local children's hospital and in Columbus. For nearly a year we have been spending time each month in and out of the hospital. That definitely took a toll on everyone in our family. My husband continued to work while I was in the hospital with whoever needed me at the time. We are blessed with Grandmas who would always jump in and take the other girls when needed.

There have been many times when a doctor or surgeon would tell us they figured it out and all would improve and we would be so happy. Then, sadly, things would decline again and I would be devastated. Watching my girls go through so much without answers is very, very hard to do because I have no idea if I am doing right or wrong in the choices I make for them. There are days I truly do not know if I can do it. All three girls require interventions every day to keep them healthy and out of the hospital. It can quickly become overwhelming. Thankfully, we have family and in home nursing care to help me but even then I feel like a failure because as their mom (and a nurse) I should be able to do it all. But clearly, I cannot.

When we first came to Columbus I was scared and praying they could help my daughter because our local teams were out of answers. We were welcomed in the Ronald McDonald House with open arms and felt as if we were truly in our home away from home. Every trip we

have made over the past few years, the staff have spoiled my girls. My oldest daughter, Lily, was at RMH last summer when we met Molly. Lily was so excited to have a quilt made of her drawing! After we turned in the drawing she was as patient as a 10 year old could be until her quilt showed up in the mail. And she has been in love ever since. Lily is my artist and she spends her free time drawing so this quilt means even more to her to see one of her drawings come to life.

Here are my girls in their crazy glory!

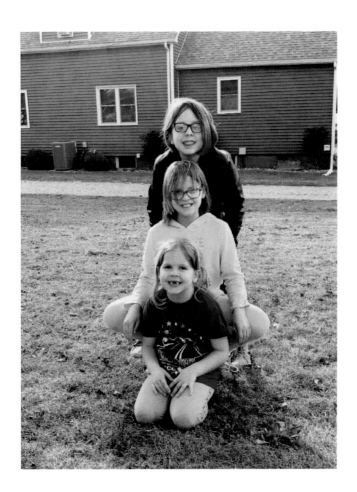

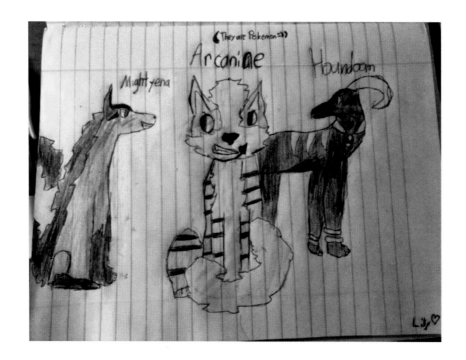

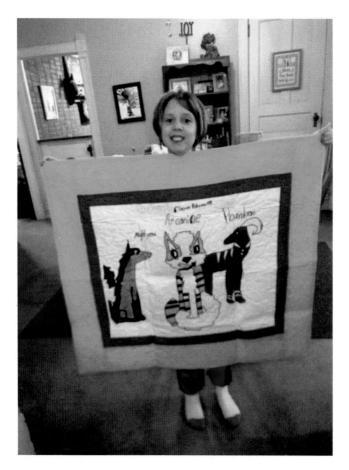

One Sunday evening while I was visiting the Ronald McDonald House, a lovely woman

approached my little display table and looked carefully at the examples I had laid out. Her

name was Tina and she told me about her grandson, Eric. She is raising Eric who has severe

Scoliosis (Curvature of the Spine). He would be having yet another surgery to try to improve his

limitations. She thought he might enjoy making a picture for me and agreed to ask him.

In Tina's words............. Eric was diagnosed with scoliosis at the age of 9 in April 2014. The

family was concerned about how this situation would be treated. Eric has had a total of 3

surgeries. The first surgery was on August 12th 2019. It was successful in putting in the

hardware for the rods that would straighten the spine. The second surgery 2 days later caused a

loss of movement in both legs. Eric spent 6 weeks in rehabilitation learning to walk again. 3rd

Surgery was on December 10th, 2019 and the rods were put in place. Eric spent 7 days in the

hospital.

He was working in therapy and one day he decided to see how he would do without his rehab

equipment and he did excellent so he left rehab on September 26th, 2019. It was originally

scheduled for October 10th, 2019.

Eric says the black in his picture represents the pain he was feeling when he was in the ICU, not

being able to do anything and having mixed thoughts and dreams due to the medication he was

on in the beginning of the surgery process. The other colors represent the joy of moving forward

in rehab and progressing his way back to the way he was but better.

Eric was a little frightened by the clowns at Ronald McDonald House but he eventually got

used to it. He was a little scared by the things at the hospital but when he got to rehab he loved it

even more.

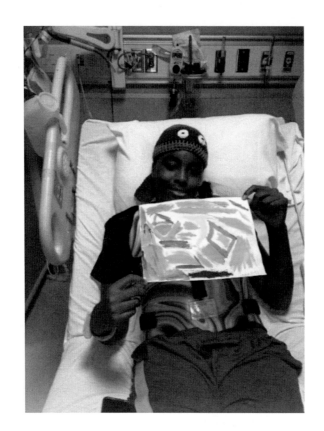

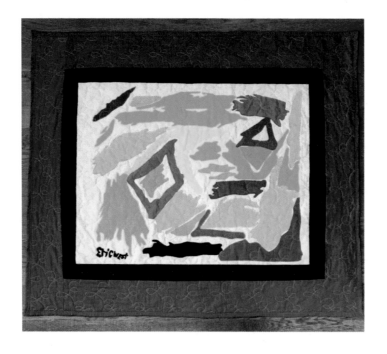

Another Sunday evening at Ronald McDonald House, I met Marta and Maria and their parents, Ana Maria and Gustavo. Marta was in a wheelchair and her little sister was walking. Although, Mom and Dad didn't speak much English, we were able to communicate with a lot of pointing and one word statements and questions. I learned that the family had come from Spain for treatment at our Children's Hospital. It was their third visit and they had come every three months. Both girls were being treated but I did not learn anything about their diagnosis. Gustavo was very happy when he told me "only two more times to come!" I rubbed my fingers together in the Universal sign for money and said something about how expensive this travel must be for him. He understood and told me, "Oh no. No………pharmacy trial…….pays for travel".

About a week later I delivered the quilt that I had made from the picture they had texted me. Gustavo and Marta met me at the reception desk in the House. It is a memory that I will keep for all of my life. Gustavo pointed at the quilt, and with arms sweeping widely he said these words. "**This** is great **remember**……..of you……….of here……….of all!" As I bowed slightly and turned to leave, the tears began to fall. Imagine, someone thanking me for such a tiny gesture when their lives are so filled with the tragedy of sick children. I cried all the way home in my car. The delivery process continues to be very difficult for me but I am working to make it less uncomfortable.

Many months later, I ran into the family again. They were back for what they told me was their "last" visit for treatment. Gustavo said, with excitement in his eyes, that the "blanket" was on the "back of………couch" at home in Spain. Gustavo was always smiling and friendly and

cheerful when I saw him. You can see that twinkle in his eye in the picture I took that morning.

I surely hope that the treatments for his girls were successful and that the reminder my quilt

gives, is one of health.

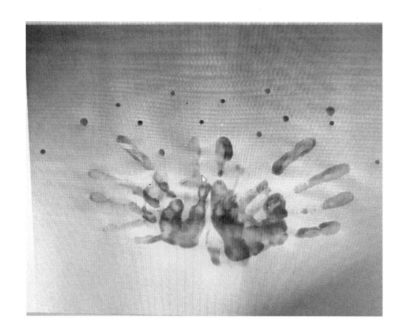

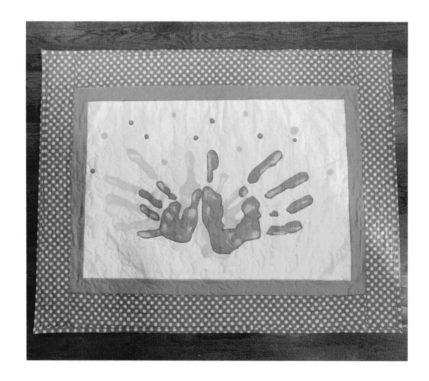

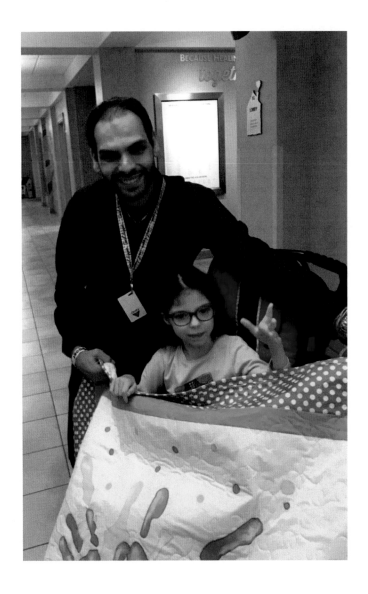

While one of my quilts is in Spain, another was taken home by Saleh and his family to Iran. I

met Saleh, his mother Fatima, and brother Faris at Ronald McDonald House on my very first

visit. Fatima had a phone that could translate my English as I spoke into it. Then, with the tap

of a button, she could speak her native language (not sure what it was) and the phone would

type out English on the screen. In this slow but effective way, I was able to explain what I do.

At first, Fatima was shy and uncomfortable. When I asked where home was, she replied

"Persia". She made it clear that the family would be staying at Ronald McDonald House for several weeks while Saleh was treated but did not discuss the details of his illness. Eventually, I was successful in my communication and Fatima bent down to talk to Saleh about making me a picture. His head bobbed up and down and a small smile appeared on his serious face. With a group of other interested families waiting patiently, I knew that I would have many quilt requests before I left that evening. For this reason, I was not able to offer little Faris his own quilt but he seemed to take the news without emotion. And, the next day, I received a texted photo from Fatima. When I look at Saleh's drawing, I am reminded that certain images are familiar to all cultures on this planet and that all children depict those images similarly.

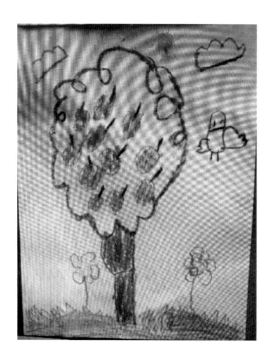 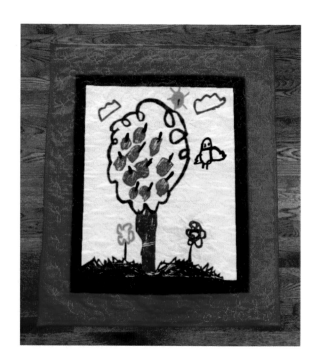

I made a quilt for a young artist named Kayden. I learned that he was with his grandparents at Ronald McDonald House, waiting for his baby sister to be released from the hospital. Kayden was just full of personality. His grandfather suggested that he might want to make a painting with his handprints on it but I could tell that he was full of ideas. A few days later I received the photo from Kayden's grandmother, Tasha. His artwork did not disappoint!

In Tasha's words……….. Nicole who is Kayden's mom, was herself born with Biliary Atresia, which is a liver disease. She was not expected to live past the age of three but many surgeries and hospital stays later, she made it. She had Kayden when she was 16 and was not supposed to ever be able to have kids. Kayden was born on September 4th 2010. He was a miracle himself. As Cole (Nicole's nickname) got older, her liver got worse. Treatments and medicine stopped helping her. In 2016 Nicole was told that her only option to make it was to have a liver transplant. Although, at the time we were going to Cleveland Clinic, they told her that her numbers were not low enough to be put on the transplant list. So, she looked into other options and was accepted into the OSU transplant team. In early 2017, Cole was told that she might make it through the year without the transplant. She and Kayden started doing all kinds of things together, not knowing what would happen. Then one day, on their way to Newport Aquarium, Nicole got a call from OSU asking how soon she could be there.... They had a liver! On March 19, 2017 we all rushed to Columbus and Nicole got her second chance at life. All the while Kayden had spent his whole life watching his mom struggle in and out of hospitals. He was more than happy to give up his day at the aquarium. After that, life was great.

Rejection medicine was working. She was able to do daily things with no pain. Then in 2019, she started getting sick and doctors worried that her liver was failing. Kayden was so scared and worried about his mom. They could not find out why Cole was feeling sick. They never thought to do a pregnancy test because she had been told there was absolutely no way, with her rejection medication, she would be able to conceive a child, let alone carry one. After medication adjustments, she was still sick. Finally, Cole went to the ER again and they did a test, and low and behold ... miracle # 2! Only this time it was rough. The doctors tried to talk her into terminating her pregnancy and told her that there could be complications and her health was at risk. She said no way.

Cole had to stop her rejection medication which caused her to be ill and in pain and she had it rough. Mid pregnancy, they started to worry the baby was not gaining weight. There was concern for the health of both mother and child. At 24 weeks, Nicole started having contractions but they were successfully stopped. Ultrasounds then showed that the baby had a hole in her bowls and that she would need surgery as soon as she was delivered. A trip to OSU was scheduled for a C-Section and plans for the baby to go to Nationwide Children's Hospital were all set in advance. One week later, Nicole was in a car accident and got thrown into labor yet again. This time they had to transport her to OSU but again the doctors got things under control and she was able to come home after 4 days. Three days later, Cole was back at the local hospital with contractions again. This time her water broke and she was taken by Careflight to OSU for an emergency C-Section. Delilyah Sue Rose decided she was coming even

if it was six weeks early. Born Jan 6, 2020 at 1:16 pm, she was at OSU NICU for a few hours and then taken straight to Nationwide Children's, where she was prepped for surgery. Then the cat scan results came back - the hole was closed. The power of prayer and God's work at hand.

Delilya was only a little 5 lb. preemie., weak and jaundiced, and not able to keep food down. Of course, Kayden was not allowed in the hospital due to his age. He was so worried about his mom and now his baby sister. He is the man of the house, the protector. He wanted to be there so bad, he was worried something would happen and he would not be there for his mom and sister. So, that is why my husband and I got the room at the Ronald McDonald House and brought him down there to stay. Diliyah spent three weeks in the NICU. Kayden patiently waited across the street, till he could finally see her and hold her.

The whole protector thing came about, when Cole was Careflighted to Ohio State University Hospital when her water broke. Kayden wanted to go and couldn't. He cried and said, "Who is going to protect them if I am not there?" So when he found out his sister was born, the same thing happened. He felt like he had to go to protect her. Kayden was proud the night he made that picture and he knew from the moment we met with Molly, what he wanted it to say. When it came in the mail, I called him and as soon as he got on the phone, he goes "Is it here?!" He knew. I told him yes , and he cried, "Come now!" To this day, that quilt is used daily and will be forever cherished.

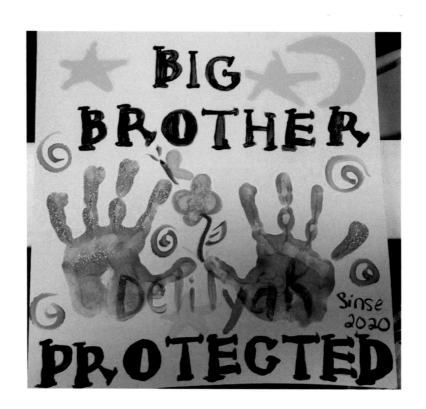

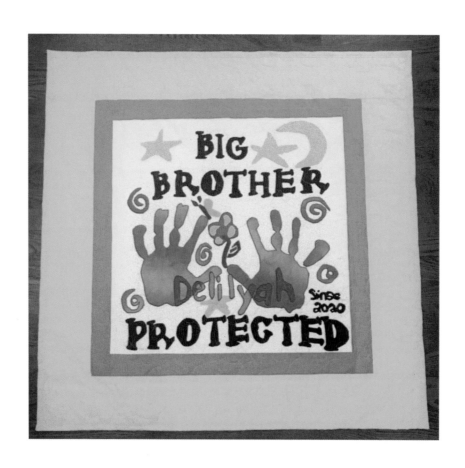

Amber approached me one Sunday evening at Ronald McDonald House and listened to me describe my love of duplicating children's original artwork in quilt form. She signed her name on the page I had typed up and attached to a clipboard, took one of my business cards, and texted me a photo a few days later. When I spoke with Amber, she told me that Maverick was her young grandson. He had been diagnosed with a rare form of cancer called Neuroblastoma. She told me that his condition would, most likely, prevent him from living a long life. I created Maverick's quilt and sent it off to him along with prayers for a healthy future.

Approximately nine months later, I contacted Amber about my idea to write a book because I wanted to include Maverick's story. I learned at that time that Maverick had passed away just two months prior. He had not even reached his third birthday. I had no words to express my sorrow then. Nor do I now. God bless you, Maverick.

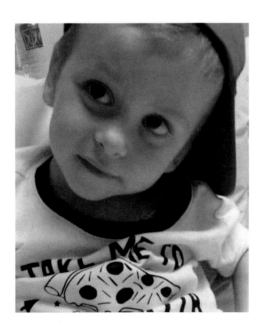

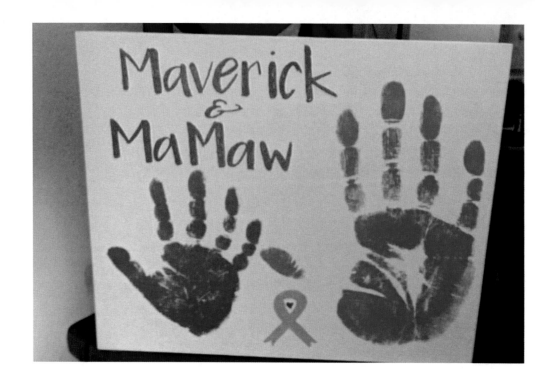

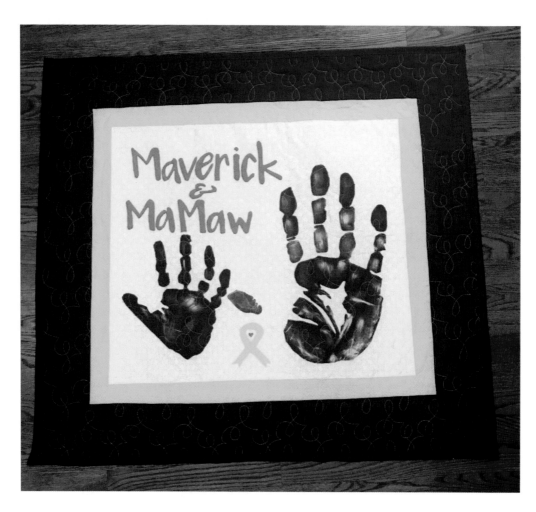

The Process

After I have received a request and I have spoken to the child who created the artwork and I have been given their permission to copy their work, I ask that a picture of the artwork be texted to my phone. That's all I need. A picture of the original artwork on my phone. And I'll discuss that further in a moment.

My first task is to study the artwork. I have decisions to make that will require some analysis. I'm looking at several aspects of the work but the first is the medium that the child used. My goal is to recreate the work as accurately as possible. Every "mistake", as some would say, adds charm and whimsy and I want to include them all. I want my quilt to look as

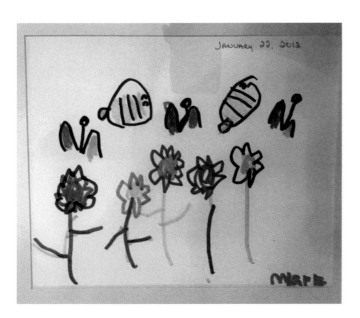 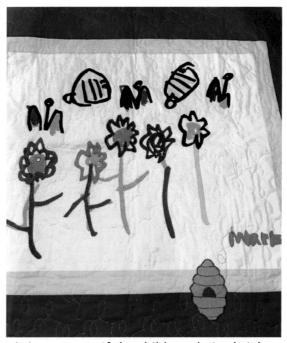

much like that original as I can make it so the medium is important. If the child used nice bright

markers, as in Marie's "Bees and Butterflies", my work is fairly simple. I'm going to be able to

use basic fabric pieces to represent that. If you look closer, you will be able to see that Marie

used two different yellow markers. One was a bit brighter than the other. I have chosen a

yellow patterned fabric for that brighter part because from a short distance it reads as the

same bright yellow as the marker. I allow myself any artistic license that I believe makes the

quilt look more like the original from a short distance.

 I also, frequently, add a small personal touch to the border of the quilt. I feel like this is sort

of my signature as the quilt artist. Also, I want to say here that most of the kid-art you see will

be on white paper. Just to add a little interest, I frequently use a white on white patterned

fabric for the background instead of plain white. But back to studying the medium.....

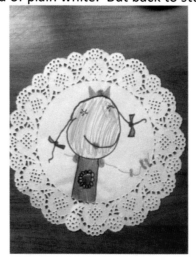

This is Carmen's Doily Girl. Carmen used markers too. But as you can see here, Carmen's

technique is a little different than Marie's.

Carmen used the red marker in a kind of scribbly way to make her face. I want to think of a way to replicate that as closely as possible. Of course, there are options. I could cut out a big red shape of fabric and then try to cut away all of the white spaces. I could try to recreate it with miles of red strips sewn on individually. But I chose to look for a product to help me and I found Tulip Fabric Crayons. They are heat set with an iron and are fully washable. I was able to achieve a fairly similar look with the Fabric Crayon. Sometimes, the quilts I make are going to be used as art and will hang on the wall. Sometimes, they are going to be used to snuggle in but I want them to be washable either way.

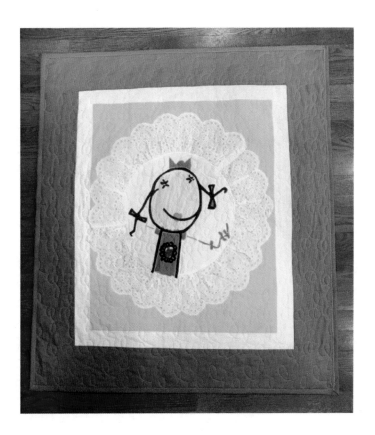

This mouse picture was done with watercolor. It means that there are several shades of brown in the original based on how watered down the paint was. So, I simply squint my eyes while looking at the picture and I can see general shapes of color. Then I make those shapes with fabrics that appear to mimic the closest shades of brown. Maybe you can see in this photo that I've used a solid and print in the face.

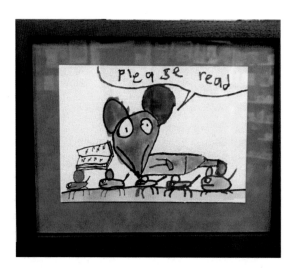

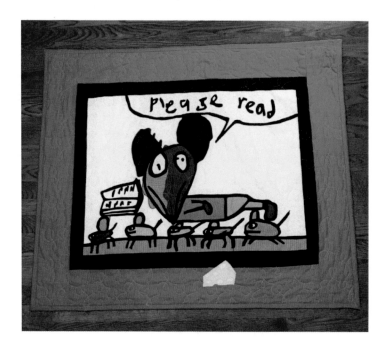

The next quilt presents some new challenges. The medium used is tempera paint. So the

colors are; not only a variety of values, but also a variety of textures. Some places are nice and

solid while others show obvious brush strokes.

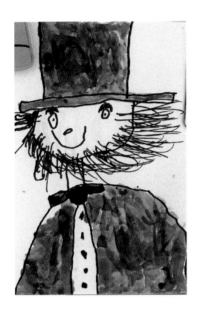 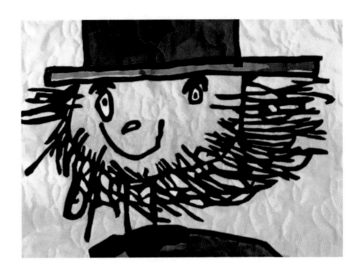

After spending some time analyzing this picture I decided to use the "squint and find large

shapes of color technique" that I use with watercolor. Then, over the top of Abraham's hat and

coat, I wanted to show those brush strokes. I found Jacquard Textile Color. It's an opaque

paint and, again, I've tested it for its "washability" and it passed all tests! I used a wide, flat,

sponge brush to just sort of dab over the fabric.

Abraham's beard was great fun because it was a heck of a challenge and I love a challenge.

After considering several options like the Tulip Fabric Crayons, I decided to tackle it this way. I

cut out one giant shape of black fabric. Then, I used scissors to cut away the larger holes. It

was not practical to cut the tiny white spaces because if I made a cut, I was going to have to stitch the exposed edges. So, I used a brush that actually has about three hairs in it and I painted the white Jacquard Textile Color onto the black fabric. Even when you study this quilt closely, it's hard to tell which spots are painted and which are cut away so it worked out well.

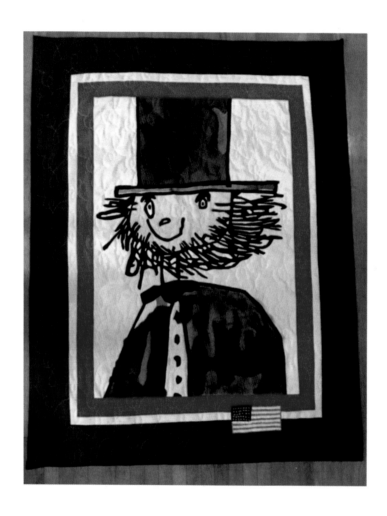

You may remember me telling you that I like to sometimes add a little something on the border of a quilt as my artistic signature and on Abraham, I added an 1861 flag, complete with 39 stars. I thought maybe it could be a little history lesson for the child who drew this picture.

The last example was actually my greatest challenge to date. Robby's picture was created with finger paints and was signed by the artist with his feet. The translation of this picture took multiple "do overs". I used bleach on the blue fabric of his footprints and it worked perfectly. But when I tried it on the green fabric, it turned a bizarre yellow color. In the end this piece was achieved by a combination of bleach, fabric crayon, fabric paint, and fabric markers.

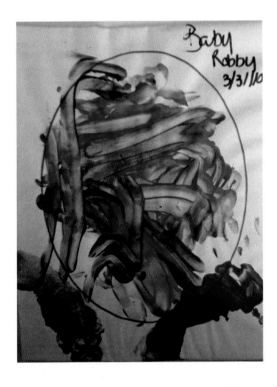
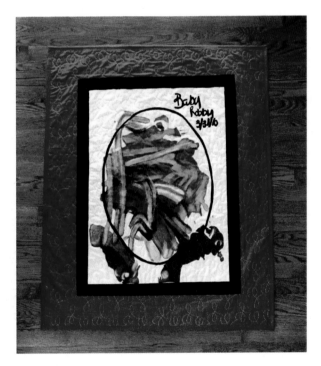

OK. So we've analyzed our artwork and determined what our approach will be. Now it's off to the fabric store. I want to emphasize here that you take the artwork with you to the fabric store. Take the original if you can but if not, make sure you have the photo that is on your phone. You will want to match your fabrics as closely as you can and you'd be surprised at how many small prints appear as solids from a short distance so don't be afraid to use those. I would also encourage you to decide what fabric you will use for your back, your border or borders, and your binding, and buy those up front with the other fabrics. I have had it happen that I decided late in the game to make a border from a fabric that was within the picture and when I went back to get more, it was no longer available.

The next step is to make a pattern for the quilt. I use a small projector that I bought at Staples for about $129.00. It's called an HP Mini. I also bought a little cord that allows me to plug my phone into the projector. Any picture on my phone can now be projected on to a wall. On the wall I hang a piece of tracing paper. I buy tracing paper in large rolls that just happen to be 24" wide. Because of that, I make all of my quilt pictures 24" x Something. After that I can add as much border fabric as I want to make it bigger. The shortest side of the artwork becomes 24" whether that's the top or the left and the longer side becomes most often about 30". It depends on the paper the child used. So I use some blue painter's tape and I tape a piece of tracing paper on the wall. Then I shine the photo of the child's artwork on to the paper and I wiggle it around until it fits. Then I trace.

Let me add a quick sidebar here: I have had two different people call me about this so I want

to remember to include it. Most smart phones are set to turn themselves off after just a few seconds. You will need to set your phone so that it stays on until you turn it off manually. I googled how to do this for my specific phone model and I found simple step by step instructions. If you don't do this, your tracing step will become very frustrating.

We will use a painting of George Washington for our example in this section. A special thank you to Lochlan. He loves Presidents and painted Abraham, shown earlier, and George.

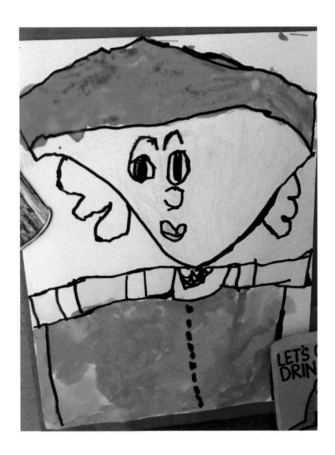

Now, because we did our "up front analysis" of the medium, we know a little bit about what shapes we want to trace. Obviously I will trace the shapes that are different colors. But since George Washington, here, was done with tempera paint, there are areas in his blue coat that

have different values. In my first analysis, I saw that and purchased different fabrics to match

these different values. So now, as I'm making my pattern pieces, I will squint again and trace

those shapes of light, medium and dark blue.

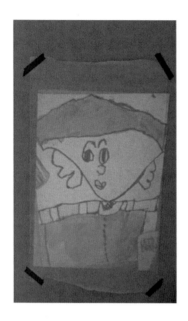 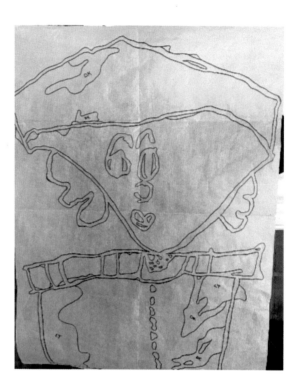

When I'm finished tracing and remove the paper from the wall, it looks like this. I have gone

over all of my original pencil lines with sharpie so that you can see this better but normally, it

would just be pencil lines.

This is my MASTER PATTERN. I protect my Master always and NEVER ever cut it up. In fact, I

have every master pattern from every quilt I have ever created.

So, let me show you how we will use this Master Pattern. I have chosen a white, pin dot fabric for the background. I have used spray adhesive to attach it to some medium weight interfacing and we will build the picture on this base. Something like a Pellon 830 works very well. This background is probably about an inch larger than the Master all the way around.

Now, I have some more analyzation to do in order to move forward. Because my goal is to recreate this image as closely as possible, I want to determine what colors the child painted first as opposed to later. In other words, which colors appear to lay over others and which lay underneath. It's easy to see on George that the artist could have added the black lines last. They are over all of the other colors. And I can see some places where the blue color lays over the top of the yellow. So I'm going to begin this quilt by appliqueing the yellow areas first. I will take another piece of tracing paper. I can lay it right over my Master and trace each of the yellow shapes. Now those shapes become the pattern pieces that I will pin to the yellow fabric and cut out.

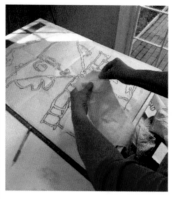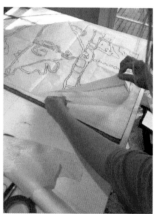

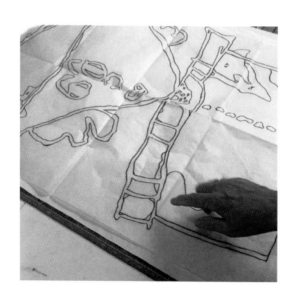

At this point I really need my Master Pattern again because I'm going to lay the Master on

the background. I'm going to slide this little piece of yellow under the Master and find the

exact location where it fits. Then, I'll use a couple drops of fabric glue and glue it down. I've

tried lots of glues and glue sticks. I really prefer a product called Quilter's Choice Basting Glue because of the long skinny tip for application.

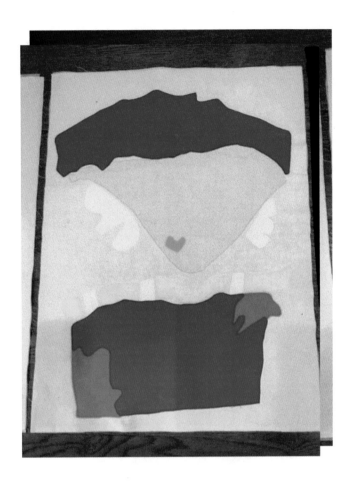

I like to go ahead and stitch a piece once I have it cut out but you could also cut out every piece of fabric and then sew it all down at one time. The order of your work wouldn't matter at all. Here, you can see I've glued and stitched down all of the yellow for this quilt. I use a basic zig-zag stitch to outline each piece of fabric. I use a length of .3 and my width varies a little but most often I use a width of 2.5 or 3.

Next I would do the face and I used a small overall print fabric for George's face even though the original is kind of scribbly. I added the light blue, the medium blue, the dark blue, the white, and the pink lips.

For George's right eye, I would use one solid piece of black fabric. I would NOT cut out the whites of his eye because I'm going to lay this piece over the face fabric which is NOT white. So I would wait till everything is stitched down and create the whites of George's eyes with white fabric paint.

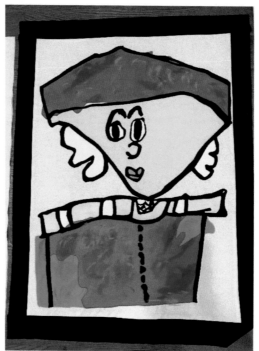

Just a reminder that we really want those "less than perfect spots" to show because they are what make kid's art so appealing. And here's the final picture.

After the fabric was all sewn down, I used some blue fabric paint to add texture to the hat and coat and of course, I added the whites of the eyes. Now, you can add as few or as many borders as you like.

At this point we can make our "quilt sandwich" of batting and a back fabric. Then we will quilt the overall piece. Then we will square it up and bind it. Then we will add a sleeve and rod if the piece is to be hung. And my personal final step is to create labels for the back. I want the world, years from now, to know who created this work so I use the lettering feature on my sewing machine and I stitch out "Original Artwork by _____ and Art Quilt by Molly Todd and I add the date. I have also found a product called Bubble Jet. It allows you to run fabric through your printer. I put a copy of the original artwork (printed on white fabric) on the back of each quilt. The picture and two labels are simply hand stitched on to the quilt.

Here is what George looks like as a finished quilt, ready for hanging.

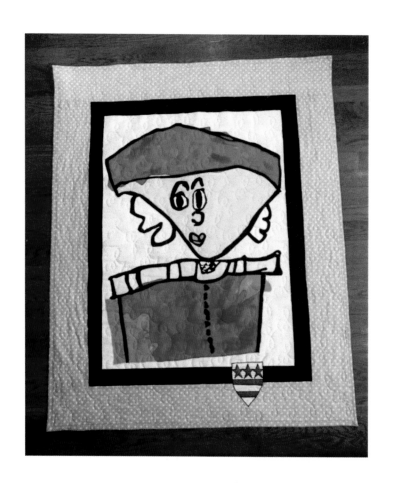

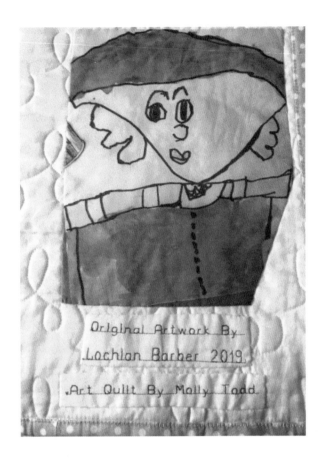

Original Artwork By
Lochlan Barber 2019.

.Art Quilt By Molly Todd

I have added the Washington family crest as my "artist's signature". In my research I

discovered that the President used this symbol frequently. Also, I have added labels to the back

of the quilt. Project complete!

Threads of Life

Conclusion

Sometimes, we set off on a journey with a very clear idea of where we are headed and why we are headed there. Most often, we are surprised when the journey unfolds. I know you know this. My quilt journey has been more of a surprise to me than I could ever have guessed it would be. The purpose of this book is threefold. I want to share with the world, the surprise and vast range of emotion I've experienced while on my journey. I also want to provide a forum for the families I've met. A forum in which they, too, might share. And lastly, I want to provide step by step instructions for my fellow art quilters, lovers of fabric, and appreciators of children's original artwork.

In the process of bringing this book to fruition, more and more families have expressed their desire to be included. Each of these families has a story all their own. Each in a unique space along the spectrum of diagnosis and treatment for their critically ill children. For many, now is not the time to write. Not the time to share.

For these reasons, I will complete my thoughts and move these pages towards publication. But, I will also make a promise to you, my readers. Other books will follow soon. They will focus on the families I sew for and will hold many more stories of strength and bravery. In the meantime, as you meet the daily challenges of your own life, I encourage you to give a thought to the ten families you've just met. Be positively motivated by them. And, don't forget to feel the pure pleasure that puts a smile on your face when looking at the creations of a child.

In conclusion, I will leave you with this. I recently read in a quilting magazine, a question. It was in big, bold print and it asked, "Where do you find inspiration?" There was a wonderful list of responses that included everything from nature to architecture to books to other quilters. I am inspired by the whimsy and the honesty and the "freeness" of children's artwork. I'm beyond honored that you have allowed me to share my inspiration with you and I hope that, just maybe, you will be inspired in some way. Perhaps, you will even chose to join me in the fun. I do hope so.

About the Author

Molly M. Todd

Art Quilts by Molly Todd are born of passion. Her love of children's original artwork and a lifelong fascination with fabrics combine to allow her personal expression and creativity.

Molly holds a Bachelor of Art Education and a Masters in Middle Childhood Education from The Ohio State University. She is also licensed in Elementary Education and Mathematics Education. After 23 years in the middle school classroom, she spent three years as an adjunct in mathematics at the university level. She was recognized, nationally, in 2001 as a Disney American Teacher Awards Nominee for mathematics.

Upon retirement, Molly was led to become a quilt artist through a series of unlikely events. She considers these events spiritual in nature. Retirement has given her the time to translate children's original artwork into quilt legacies. Her paying customers allow her to create gift quilts for critically ill children at Ronald McDonald House Charities of Central Ohio. She is honored to be associated with these strong families and brave children.

Learn more at artquiltsbymollytodd.com

Contact Molly at mtodd@columbus.rr.com

Made in the USA
Columbia, SC
10 April 2021

35958621R00033